DOUBLE EXPOSURE

THROUGH THE AFRICAN AMERICAN LENS

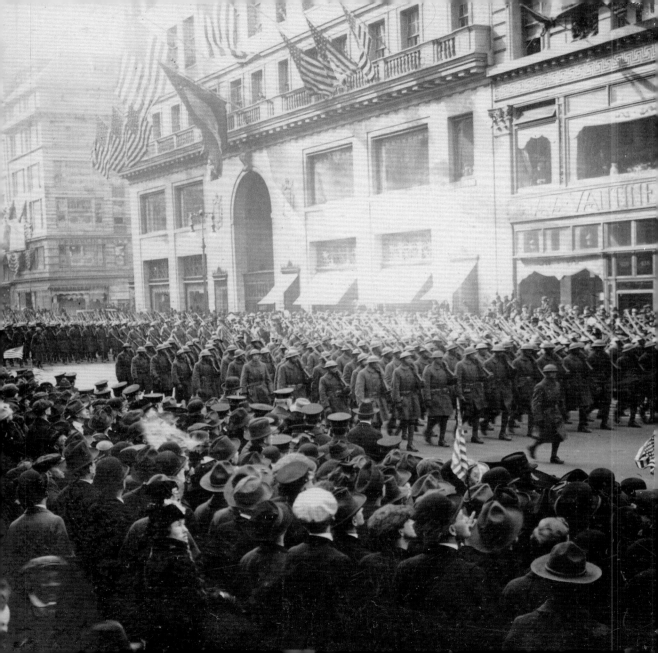

DOUBLE EXPOSURE

THROUGH THE AFRICAN AMERICAN LENS

Smithsonian
*National Museum of African American
History and Culture*

Earl W. and Amanda Stafford
Center for African American Media Arts

GILES

National Museum of African American History and Culture
Smithsonian Institution, Washington, D.C., in association with D Giles Limited, London

For the National Museum of African American History and Culture
Series Editors: Laura Coyle and Michèle Gates Moresi

Curator and head of the Earl W. and Amanda Stafford Center for African American Media Arts: Rhea L. Combs

Publication Committee:
Aaron Bryant, Rhea L. Combs, Laura Coyle, Michèle Gates Moresi, and Jacquelyn Days Serwer

For D Giles Limited
Copyedited and proofread by Jodi Simpson

Designed by Alfonso Iacurci

Produced by GILES, an imprint of D Giles Limited, London

Bound and printed in China

Smithsonian Institution, National Museum of African American History and Culture, Washington, D.C., in association with GILES, an imprint of D Giles Limited, London

ISBN: 978-1-907804-46-5

All measurements are in inches and centimeters; height precedes width precedes depth.

Photograph titles: Where a photographer has designated a title for his/her photograph, this title is shown in italics. All other titles are descriptive, and are not italicized.

Front cover: *Photographer Zack Brown Shooting Dapper Men in Harlem, ca. 1937* (detail), Eliot Elisofon
Back cover: *July 4 March through Chapel Hill*, July 4, 1964; scanned 2010, James H. Wallace
Frontispiece: *V19244 – Colored Veterans of the 15th Regt. 369th Infantry, Marching up Fifth Avenue, New York City*, February 18, 1919 (detail), Published by Underwood & Underwood
Page 6: *Girl at Gee's Bend, Alabama*, 1937 (detail); printed 1981, Arthur Rothstein

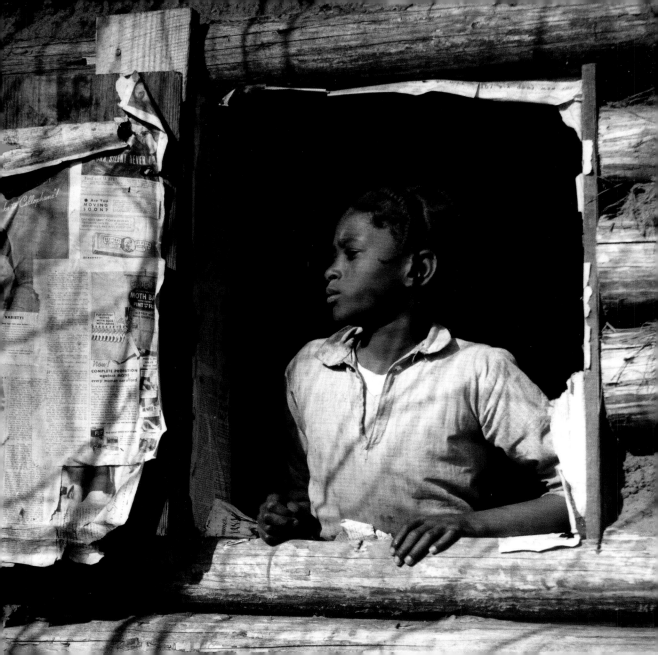

Foreword

I am delighted to introduce this book of more than 60 images selected from the National Museum of African American History and Culture's still-growing collection of over 15,000 photographs. The ability of photography to convey the great range of American experiences helps contextualize the dynamic history of blacks in America. As a museum of the twenty-first century, NMAAHC will need to steep itself in the rich visual medium of photography and make it an essential part of its collections.

Through the African American Lens launches a series of publications, Double Exposure, which draws on the Museum's photography collection. This first volume highlights the breadth of material in the collection and spectacular images reflecting the diversity of the African American experience. Noted scholar of photography Deborah Willis has been a key collaborator with the Museum over the years and was essential to the genesis of this photography collection. In her introduction to this volume, she deftly frames for us the contexts for the array of images included here, and calls out a few salient ones. Rhea L. Combs, a curator at NMAAHC and scholar of visual culture, introduces the Museum's Earl W. and Amanda Stafford Center for African American Media Arts (CAAMA) and discusses the significance of self-representation so evident among the featured images.

The power of photographs is not only the ability to depict events, but to bring human scale to those experiences, from the everyday pose for a snapshot to the extraordinary gathering of mass demonstrations. Looking over this modest selection of over 60 photographs, I am struck again by the power of images to move us, and to put faces and personality to historic moments.

Many people contributed to the making of this beautiful book and landmark series. At the Museum, special acknowledgement is due to the publications team: Jacquelyn Days Serwer, Chief Curator; Michèle Gates Moresi, Curator of Collections, who acted as team leader on this project; Rhea L. Combs, Curator of Photography and Film, and Head of the Stafford Center for African American Media Arts; Laura Coyle, Head of Cataloging and Digitization, whose work made the reproduction of these photographs possible; and Aaron Bryant, Mellon Curator of Photography.

We are also very fortunate to have the pleasure of co-publishing with D Giles Limited, based in London. At Giles, I particularly want to thank Dan Giles, Managing Director; Alfonso Iacurci, Designer; Sarah McLaughlin, Production Director; Allison McCormick, Editorial Manager; and Jodi Simpson, Copy Editor. We are also grateful to Deborah Willis, University Professor at the Tisch School of the Arts at New York University, for her

thoughtful essay. Others who deserve my
thanks include Lisa Ackerman, David Braatz,
Emily Houf, Erin Ober, Christopher Louvar,
T. Greg Palumbo, Douglas Remley, and Jennie
Smithken-Lindsay.

This is just the beginning. Two forthcoming
volumes in this series will focus on the Civil
Rights Movement and African American
women. We remain steadfast in our commitment
to document African American history, and
I trust that, like me, you will be inspired by the
photography collections at the Smithsonian
and beyond.

Lonnie G. Bunch III
Founding Director
National Museum of African American
History and Culture, Smithsonian Institution

*Untitled (Charles Madison,
Warrenton, Virginia)*, 1986
John Pinderhughes

*"The power of photographs is not only
the ability to depict events, but to bring
human scale to those experiences."*

Lonnie G. Bunch III

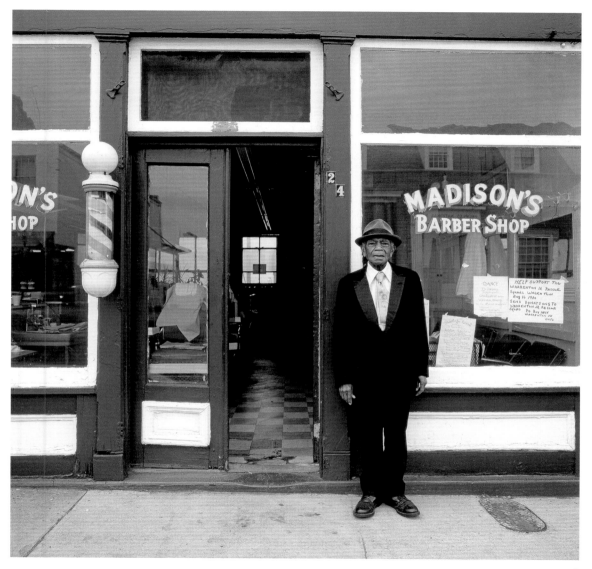

Self-Representation and Hope:
The Power of the Picture

Rhea L. Combs
National Museum of African American History and Culture

Poets, prophets, and reformers are all picture makers—and this ability is the secret of their power and of their achievements. They see what ought to be by the reflection of what is, and endeavor to remove the contradiction.[1] —Frederick Douglass

For many black people, America is complicated. A nation of promise and hope, it is also a place that has kept large swaths of its citizens on the legal and social margins. W. E. B. Du Bois described this paradox best in his 1903 tome *The Souls of Black Folk*. There he wrote: "One ever feels his twoness, —an, American, a Negro; two souls, two thoughts, two unreconciled strivings; two warring ideals in one dark body, whose *dogged strength* alone keeps it from being torn asunder."[2] It is through faith, fortitude, and focus that many African Americans have negotiated this peculiar tension. And photography is one medium that most effectively documents these noteworthy characteristics. From vintage photographs to present-day digital images, African Americans have long found agency through the power of the lens. Even in some of the most challenging moments in American history, the gaze, one's posture, a subtle gesture, or an article of clothing can demonstrate a tradition of resilience and determination. In other words, "Cameras gave to black folks, irrespective of class, a means by which we could participate fully in the production of images."[3]

Photographs also provide a sense of connection to a particular time and place. The images in this book are selected from the photography collection of the National Museum of African American History and Culture (NMAAHC) and support the Earl W. and Amanda Stafford Center for African American Media Arts (CAAMA). CAAMA, as a physical and virtual resource within NMAAHC, is an example of the Museum's dedication to preserving the legacies of black history and culture. Through its active collections agenda, which includes film and video as well as photography, public and scholarly programs, and publications such as this series, CAAMA will play a significant role in promoting and preserving African American visual culture.

This book series, *Double Exposure*, is a nod to Du Bois's notion of double-consciousness; it showcases NMAAHC's commitment to visual culture and is a re-view of African American experiences within the frame of American history. As the first book in the series, *Through the African American Lens* reflects the sweep of American history, and is a sampling of photographs from the Museum's permanent collection that honor and celebrate self-reliance, self-determination, dignity, and creativity during some of America's bleakest and brightest moments.

Power of the Image and Self-Representation

A preacher, abolitionist, advocate of women's rights, and mother, Sojourner Truth knew the power of images (right). In fact, during the nineteenth century she sold cabinet cards of herself promoting the cause of justice and equality that said, "I sell the shadow to support the substance." The slogan foreshadowed Du Bois's notion of twoness in as much as Truth understood her image was a galvanizing representation and symbol, not her complete story. Frederick Douglass, the

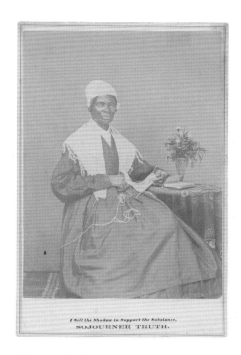

I Sell the Shadow to Support the Substance.
SOJOURNER TRUTH.

Sojourner Truth,
1864
Unidentified photographer

nineteenth-century activist and statesman, also understood the power of photography and used his well-dressed, dignified image to signify African American citizenship and humanity. One of the most photographed men of his generation, Douglass's image was captured by pioneering black photographer Cornelius M. Battey (1873–1927), who also took pictures of such prominent figures as Du Bois (see p. 19) and Booker T. Washington, among others. The National Museum of African American History and Culture is proud to have several of Battey's works, along with those of other early black photographers, in its permanent collection.

While photographs are not absolute truth, and often suggest more questions than answers, they have a power to provoke, push, or propel one to think about a historical moment, reexamine the known world, or demonstrate the possibilities of one's future. Douglass, like Truth and others among the Museum's permanent collection, realized their photographic image could create a counter-narrative to mainstream understandings of African Americans at the time. Today, these artifacts of self-representation continue to be significant; they help us to recognize critical moments within American history. Looking at portraits of well-dressed Southern men and women of the Victorian era (see p. 29),

or witnessing the savoir faire of a pair of gentlemen in Harlem during the 1930s (see p. 59), highlights a long-standing tradition of known and anonymous individuals reframing preconceptions of what it means to be black in America. The varied images within the Museum's collection reiterate a known fact about America: its identity is as diverse and dynamic as its citizens.

The Subjective Photographic Purpose
Among these pages are some of the Museum's photographic gems. The sweet smile of a mother staring lovingly at her newborn child (see p. 54) and the quiet contemplation of a church member (see p. 56) represent sacred universal experiences. The photograph of the mother and baby is particularly poignant because it also recognizes the long-standing African American midwifery tradition, a practice integral to American history and black women's critical role within the medical profession. This photograph is part of two midwifery photography collections the Museum is proud to have acquired.

In many ways, the approximately 60 images in this book—like the religious and childbirth photographs—evoke themes of birth, rebirth, and staking a dignified place in the world. The first of the featured photographs challenges us to "Open our Future," and is a

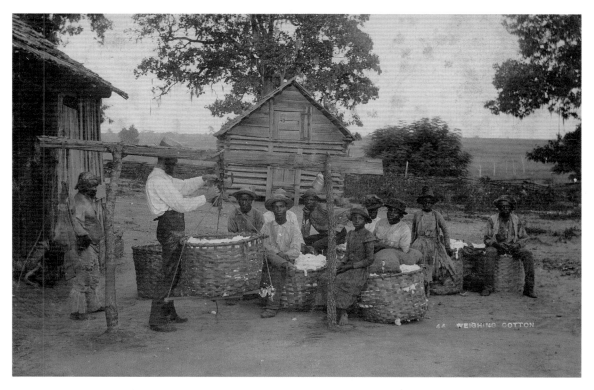

Views of Thomasville and Vicinity:
44 Weighing Cotton, ca. 1865
A. W. Möller

Alvin Ailey, 1962; scanned 2013
Jack Mitchell

rallying cry to re-vision ourselves as a society that values and promotes young people of all backgrounds in equal measure (see p. 24). Even the photograph of a cotton-weighing station in Thomasville, Georgia, reveals glimmers of personal agency (see p. 13). The photograph includes the harsh realities of sharecropping reminiscent of chattel slavery: huge bales of cotton; the white man measuring the day's hard labor; the tattered clothing, bare feet, and hats protecting the laborer from the sweltering heat. However, the varied expressions and postures of the men, women, and children sitting atop bales of cotton leave us room to speculate about each subject. The young man looking directly at the camera with one arm akimbo while the other hand is on his chin leads one to ask: Who is he? What is his name? What provoked such a coy look? There is a light in his eyes; his gaze, one of wonder and self-assurance, signals a nod of self-confidence, even within the most dehumanizing conditions. This sense of resilient self-awareness demonstrates notions of faith, hope, and determination critical to the story of African Americans. This is the power of photography.

African American aesthetics reflect many things. Among them are the ways in which people chose to represent and document life. Education, self-reliance,

ingenuity, and entertainment are important elements of African American history and culture; they have been forms of emotional, cultural, and social affirmation for blacks. Reflected throughout these pages, this can be seen in the self-assured portrait of Alvin Ailey (opposite), the visionary who started his own modern dance company in New York (and whose collection of Jack Mitchell photographs NMAAHC shares with the Alvin Ailey Dance Foundation Inc.); in the poetic photograph of writer and activist James Baldwin, who committed his life to exploring American identity (see p. 64); and in the well-groomed pride shown by a group of children whose families were displaced (see p. 31 and gatefold) during the disastrous 1927 Mississippi flood that left many African Americans and working-class whites submerged for months in Delta red clay and murky waters. It is the commitment to showing the rich, multifaceted stories of American history reflected within the images of African American life that the National Museum of African American History and Culture is proud to share.

Endnotes

1. F[rederick] Douglass Papers (ca. 1864), n.p., cited in J. Faisst, "Degrees of Exposure: Frederick Douglass, Daguerreotypes, and Representations of Freedom," *Philologie im Netz PhiN Beiheft*, Supplement 5, 2012: 90, http://web.fu-berlin.de/phin/beiheft5/b5t2.htm.

2. W. E. B. Du Bois, "Of Our Spiritual Strivings," in *The Souls of Black Folk* (1903; repr. New York: Barnes & Noble, 2003), 9, emphasis added

3. bell hooks, "In Our Glory: Photography and Black Life," in *Art on My Mind: Visual Politics* (New York: W. W. Norton & Company, 1995), 57.

America's Lens

Deborah Willis
New York University

A museum can play a major role, a very important and really vital role in helping to shape attitudes about race.[1] —Representative John Lewis (Georgia, 5th district)

In a May 2006 interview with *Museum News*, Representative John Lewis, addressing the role of museums in American culture, noted that a museum "can help educate" and "inform people." Later in the interview, speaking directly about the National Museum of African American History and Culture (NMAAHC), the Congressman continued, "It is my hope and prayer that when children and those not so young walk through this museum they will be able to feel and touch, almost smell, a sense of history. I think it would make our nation and our people a better nation and a better people."[2]

It would take a nation of leaders, museum practitioners, and scholars from across the country to envision NMAAHC and its collections. Through a series of conversations on history, memory, and cultural representation, this community would build a museum and a collection to transform their ideas and conversations into a distinct museum experience of America.

This book, as part of that experience, presents readers with select images from the first seven years of collecting photographs at NMAAHC. As a survey of photographs contributing to the Museum's Earl W. and Amanda Stafford Center for African American Media Arts (CAAMA), this publication demonstrates the impact photography has had on the ways in which people viewed Americans of African descent and how African Americans saw and see themselves. From nineteenth century daguerreotypes to contemporary digital images, from photographs capturing historic periods such as slavery, the Civil War, and civil rights events to images of everyday life, NMAAHC's growing and significant collection includes images as diverse as studio portraits, art photography, and family shots, as well as images by some of history's leading photojournalists. In addition to work by globally recognized photographers, however, the collection prizes images by lesser-known or unidentified photographers

who documented the historical triumphs, political struggles, and cultural achievements of African Americans.

Connecting the Present with the Past through Collecting

NMAAHC's photography and media collection reflects the Museum's aims to collect, promote, produce, and privilege material that emphasizes the ways in which Americans of African descent act as agents in constructing their own images. By making the collections available, the Museum's Stafford Center for African American Media Arts encourages scholars and researchers, as well as the general public, to make use of its robust collection of photography, film, video, and other media as a prism through which to explore critical formations of African American identities.

Following Emancipation and through to the first half of the twentieth century, black communities were building their own cultural centers, businesses, churches, news organizations, schools, and towns in large numbers. At the same time, groups of African Americans were migrating from the rural South to urban areas in the North and West in search of jobs and opportunities for themselves and their families. It was during this "Great Migration" that American cities adopted new racial landscapes, which these photographs revealed. We see America's history in the family portraits taken on porches, the posed scenes captured in studios and classrooms—images that recorded African American lives. From photographs of black soldiers and race leaders to images of celebrities and everyday experiences, pictures of black life and achievement are captured in this publication.

The book illuminates photography's significance in interpreting and documenting African American art, culture, and history. It aligns with NMAAHC's goal of giving a visual voice to a broader American story of hope and resilience, struggle and pain, success and triumph. In building its archive of photographs to reflect the collective history of a nation, NMAAHC is globally positioned to unearth and share American stories that resonate with every visitor.

A young woman, ca. 1850
Augustus Washington

Nineteenth–Century Portraiture

As previously mentioned, the Museum's photography collection represents an array of historical and contemporary photographic processes and techniques. Among the earliest images are daguerreotypes, ambrotypes, tintypes, paper prints, cartes-de-visite (CDVs), cabinet cards, and large albumen photographs from the 1800s. These objects include images by some of the first black photographers to work in the United States. Augustus Washington operated a successful gallery in Hartford, Connecticut, and was one of nation's first historically significant and renowned daguerreotypist. NMAAHC's portrait of Washington's unidentified woman in a high-necked dress and earrings (left) represents a fine example of the work of nineteenth-century studio photographers. It was a common practice during the 1800s for families and individuals to hire photographers to capture their image for loved ones and future generations.

Equally noteworthy, however, are photographs that help shed light on slavery and the ways in which African Americans were viewed and portrayed in the nineteenth century by others. Images of servant children holding or standing near white children, and black soldiers in military uniforms, capture America's racialized past. The familiar but

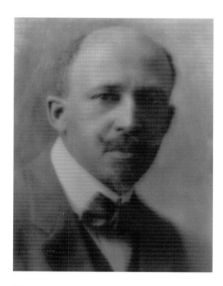

W. E. B. Du Bois, 1918
Cornelius M. Battey

rare lantern slide entitled *Gordon under Medical Inspection* offers a poignant example (see p. 27). The original image of the "self-emancipated" Gordon was taken by the photographic team McPherson & Oliver. Circulated widely through journals and other publications, the photograph portrays a formerly enslaved man, known as Private Gordon, seated on a wooden chair with his back

towards the viewer. Gordon's shirtless body shows evidence of beatings and the cruelty many people who were enslaved endured. Gordon's scars testified to slavery's violence and inhumanity, so abolitionists reproduced and sold the image to help raise money and awareness to support the antislavery cause.

Other notable portraits in NMAAHC's early photography collection include a number of historic images of heroic figures such as Sojourner Truth. There are also portraits of Frederick Douglass, Booker T. Washington, and W. E. B. Du Bois (left), all of whom were photographed by the celebrated photographer Cornelius M. Battey. Stereographs, popular from the 1850s through the 1930s, were viewed through stereoscopes that gave these images a three-dimensional effect; they are also represented in NMAAHC's growing collection. One such image features the Fisk Jubilee Singers taken during Fisk University's early history (see p. 61). As free and newly freed families and individuals migrated to metropolitan areas, they formed organizations and benevolent societies that focused on education, politics, and organized labor. NMAAHC's photography collection offers examples of these proud, hardworking, and self-reliant Americans who mobilized on behalf of the community's rights and interests as citizens.

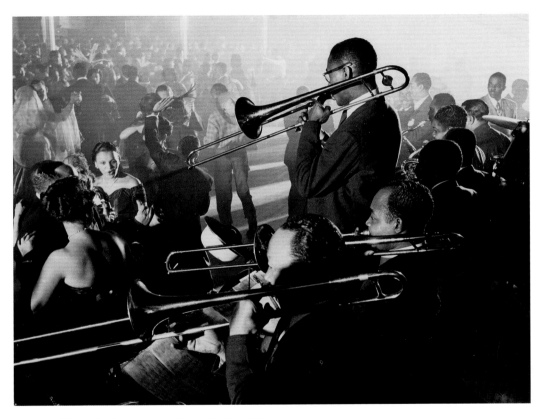

Orchestra Playing for Dancers at the Annual National Urban
League Ball at the Savoy Ballroom, New York, 1949
Gjon Mili

Transforming the American Landscape: Photographs from the Rural South and Urban Centers

NMAAHC's collection also houses a growing and impressive selection of twentieth-century gelatin silver prints and digital images that document the local experiences of everyday people. Before and during World War I, for example, the streets of locales like Chicago; Washington, D.C.; and Harlem, New York, were settings for photographers such as Henri Cartier-Bresson, Eliot Elisofon, Jack Manning, Wayne F. Miller, and Addison Scurlock. Likewise, photographers such as John Johnson, Arthur Rothstein (right), W. Eugene Smith, and Henry Clay Anderson captured views of southern life through rural scenes of families and tenant farmers, as well as hairdressers and midwives at work. Photographers working west of the Eastern Seaboard states documented the everyday and extraordinary events of people who settled in places like Yankton, South Dakota, and Lincoln, Nebraska. The Museum's images of the 1921 Tulsa Race Riot offer an example.

NMAAHC's collection also documents the artists, educators, historians, and philosophers who were recognized for their creative endeavors and accomplishments. Arthur Bedou, Lewis Hine, and others photographed the social, cultural, political, and religious events in black communities, schools, and churches.

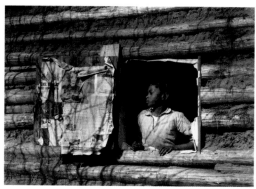

Girl at Gee's Bend, Alabama,
1937; printed 1981
Arthur Rothstein

Likewise, literary and musical artists beautifully photographed by Gjon Mili are a highlight of the collection (see p. 20).

In the late 1950s and 1960s, photographers from around the world were instrumental in motivating cultural change and defining the significance of the Civil Rights and Black Power Movements. As such, images of protest, meetings, rallies, and leading figures like Dr. Martin Luther King, Jr., Malcolm X, Fannie Lou Hamer, Mamie Till, and John Lewis are equally represented in the Museum's unique holdings. Many of these images capture America's black leaders in action, as they leveraged the press, pressured the courts, and demonstrated to challenge segregation and the laws that sanctioned discrimination. The front pages of newspapers around the world featured stories and pictures of the political turmoil of the Civil Rights era. Leading photographers of the time—Bruce Davidson, Charles Moore, and Ernest Withers, among others—are represented. Protesters in Selma, Alabama, and noted figures at the March on Washington are also part of a collective story and communal expression of protest, struggle, and triumph housed in NMAAHC's collection. The complexity and diversity of contemporary photographs in the collection capture communities and cultures from the 1970s to the present.

Prominent members of the Black Power Movement and the Black Panther Party, such as Stokely Carmichael, Kathleen Cleaver, and Eldridge Cleaver, are also part of the Museum's significant archive of images (see p. 65). These images make visual statements on modern culture, and reflect the cultural dynamics of their time; they document fashion, music, dance, and film, media, and the visual arts. Throughout history, images of people and events have shaped worldviews. The photographs in NMAAHC's collection have helped shift perspectives on American art, politics, history, and culture. The National Museum of African American History and Culture will continue to evolve this extraordinary collection as a repository for America's past and future.

Endnotes

1. Jane Lusaka, "Finding a Place: A Conversation with John Lewis," *Museum News*, May/June 2006, 65.
2. Ibid., 65-66.

PHOTOGRAPHS

HISTORY

America's promise of freedom is filled with contradiction. Perhaps no people understood this more than the roughly four million enslaved African Americans living in the United States before 1863. Through their actions, large and small, enslaved people worked toward the moment of freedom for more than 200 years, and their descendants continued the struggle into the twenty-first century. These images reflect the people, many anonymous, who sought and supported freedom in their own way and celebrated the Fifteenth Amendment that afforded the opportunities and responsibilities of citizenship.

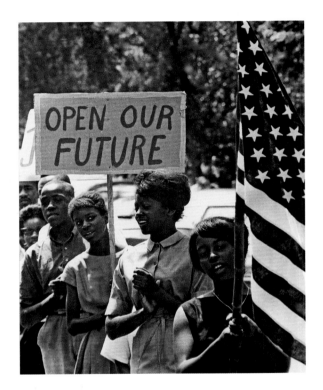

July 4 March through Chapel Hill, July 4, 1964; scanned 2010
James H. Wallace

Carrying on the legacy to demand equality and justice, the youth of Chapel Hill, North Carolina, organized frequent public protests against segregation during 1963–64.

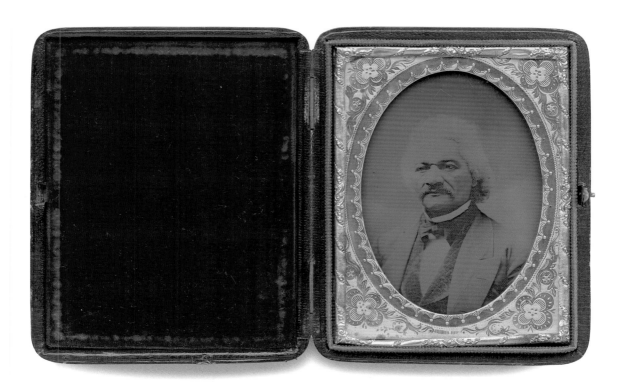

Frederick Douglass,
1855–65
Unidentified
photographer

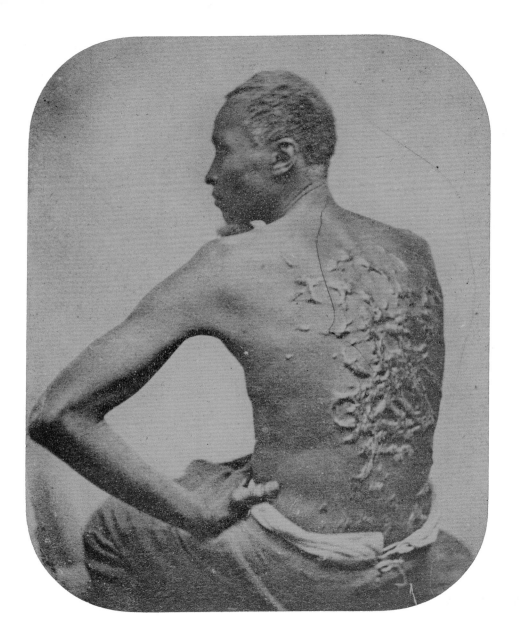

Gordon under Medical Inspection, 1863;
printed later
McPherson & Oliver

—

This is one of two famous images of the back of a runaway slave known as "Gordon," "Private Gordon," or "Peter." This version is fitted to be used in a lantern slide projector. The photograph was featured in the July 4, 1863, edition of *Harper's Weekly*, and discussed in the May 28, 1863, issue of *The Independent*.

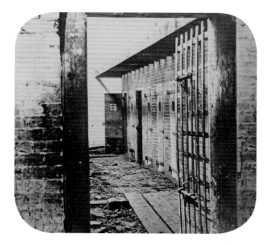

Alexandria, Virginia, slave pen, 1861
Taylor & Huntington

"The black man with the scarred back is the type of the slave system, and of the society that sustains it. It typifies the pride of race and the contempt of labor. This card photograph should be multiplied by the hundred thousand, and scattered over the states. It tells the story in a way that even Mrs. Stowe cannot approach; because it tells the story to the eye."

The Independent, 1863

**A woman with a
young boy**, 1865
Unidentified
photographer

**An African American
child holding a white
baby**, 1850s
Unidentified
photographer

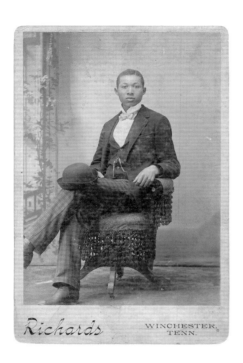

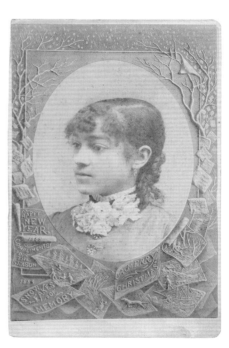

Matt Gray, ca. 1880
Richards Photography

Laura E. Singleton, 1884
W. H. Farley

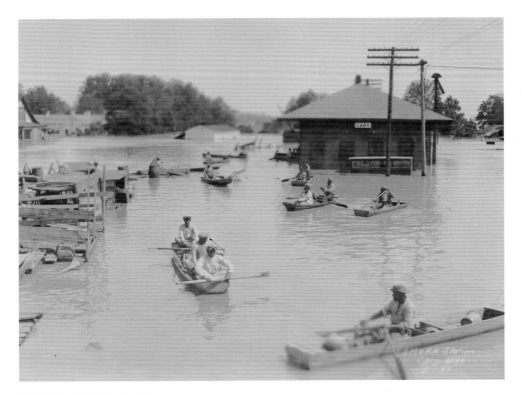

**Y. & M. V. R. R. Station Cary,
Miss. 5–1–27**, 1927
**Documentation of the
Mississippi River flood**
Illinois Central Railroad

In the spring of 1927, massive flooding along the Mississippi River created one of the largest natural disasters in American history and profoundly changed the social, cultural, racial, and economic landscape of the Mississippi Delta and of the nation. More than 30 feet of water stood over land inhabited by nearly one million people. Almost 300,000 African Americans were forced to live in refugee camps for months, and many migrated away from the region never to return.

Yazoo City Pan.
J8, 1927
**Documentation of the
Mississippi River flood**
Illinois Central Railroad

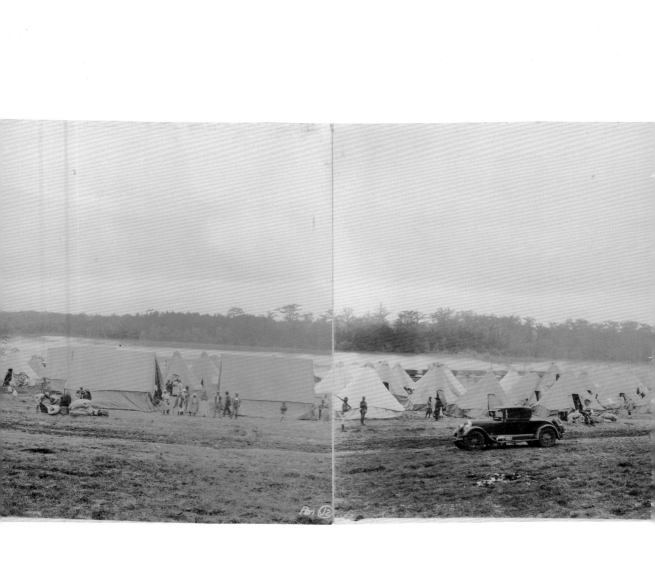

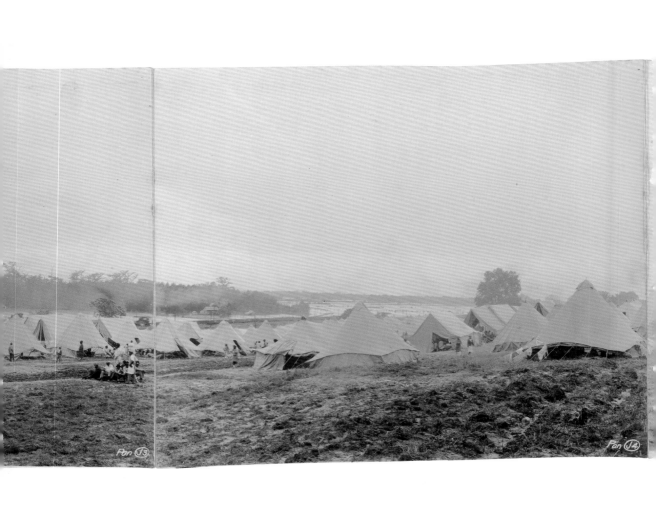

Pan 13 Pan 14

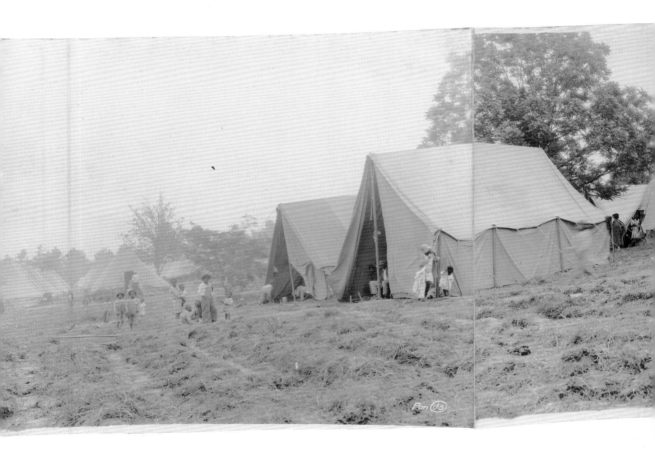

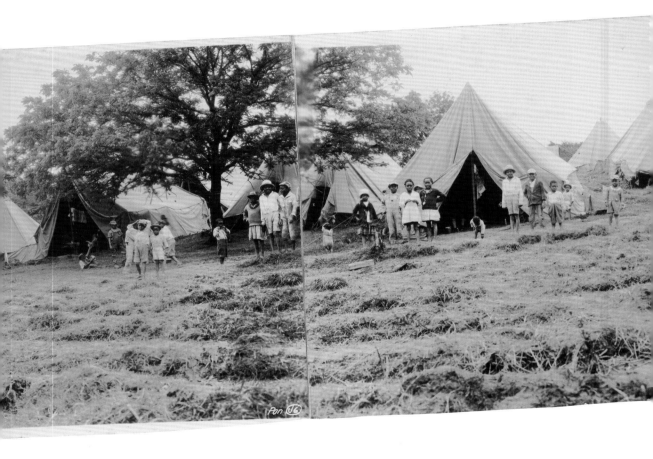

Pan V6

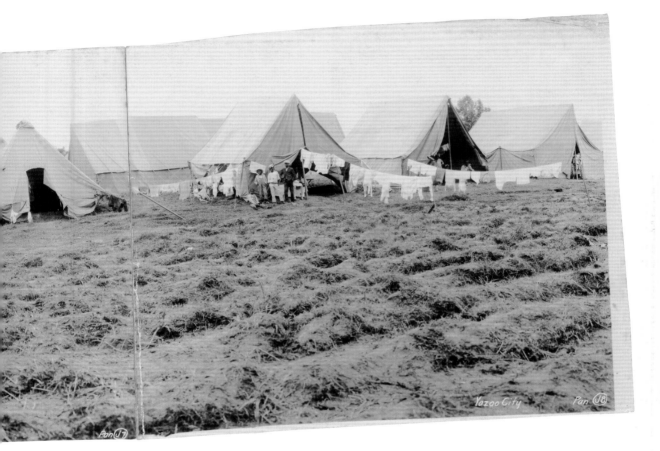

Yazoo City

Pan 18

Pan 17

*"When it thunders and lightnin'
and the wind begins to blow
There's thousands of people ain't
got no place to go"*

Bessie Smith, 1927

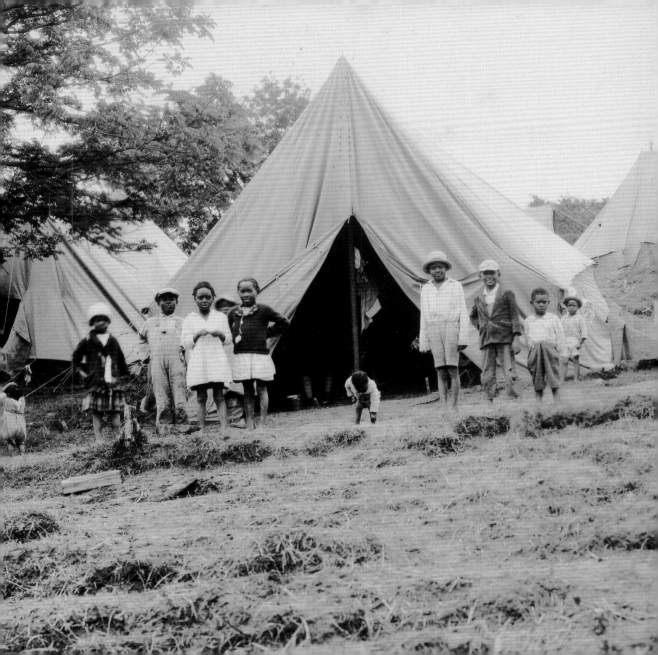

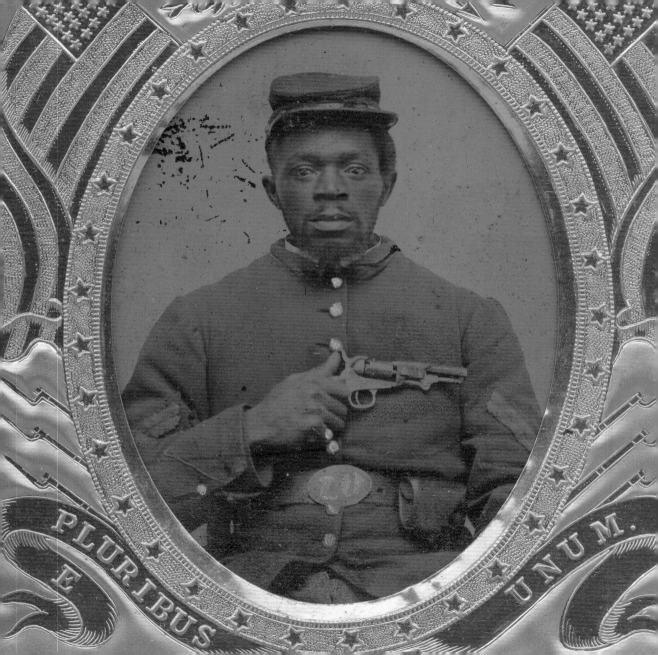

E PLURIBUS UNUM

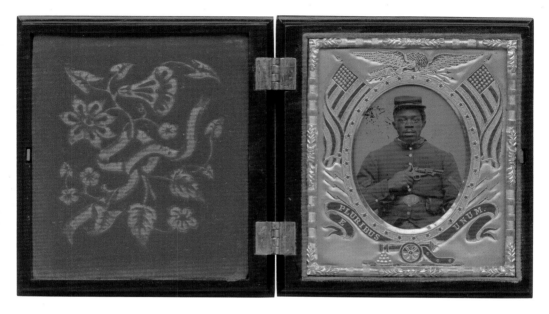

An African American soldier, 1861–65
Unidentified photographer

"Once let the black man get upon his person the brass letters U.S., let him get an eagle on his button, and a musket on his shoulder, and bullets in his pocket, and there is no power on the earth or under the earth that can deny that he has earned the right to citizenship."

Frederick Douglass, April 6, 1863

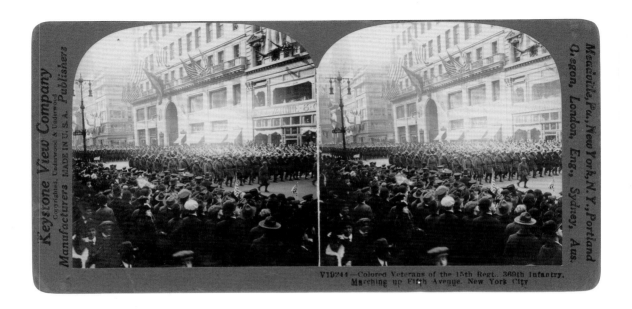

**V19244—Colored
Veterans of the 15th
Regt. 369th Infantry,
Marching up Fifth
Avenue. New York
City**, February 18, 1919
Published by
Underwood
& Underwood

Lawrence McVey, ca. 1920
Alva Studio
—
Corporal Lawrence McVey
(1897–1968), of Company D, 369th
Regiment—also known as the
"Harlem Hellfighters"—was among
the first African Americans to
reach the battlefields of World War I.
McVey earned the Sharpshooter
Badge, as well as a Purple Heart.
He also received France's most
prestigious military award, the
Croix de Guerre, for bravery on
the battlefield.

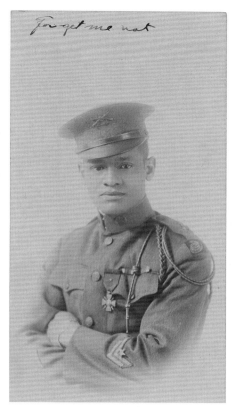

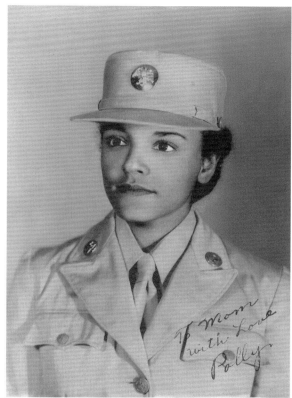

**Pauline C. Cookman
in uniform**, ca. 1950
Unidentified
photographer

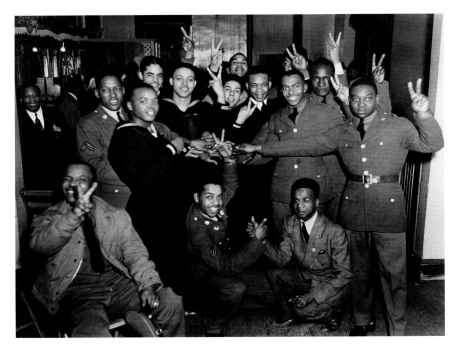

***Back from Jim Crow Army and
Navy on the Homefront***, 1940s
Joe Schwartz

*"The best interest of America can be
served only by scoring a victory both
at home and abroad."*

The Pittsburgh Courier, June 13, 1942

**An African American
sergeant marrying
a Korean woman**,
ca. 1950
Unidentified
photographer

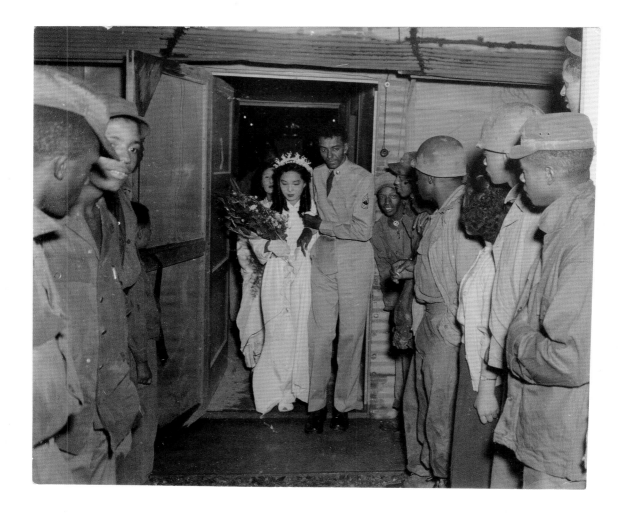

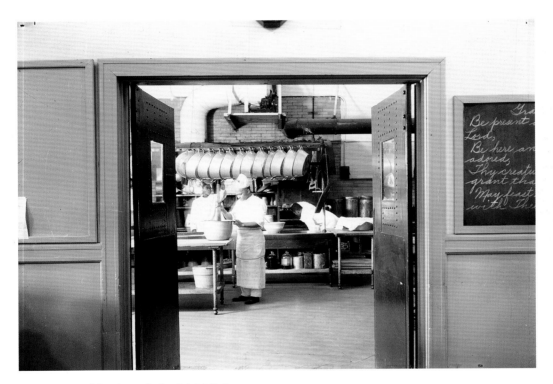

Students working in an industrial kitchen,
ca. 1935
Lewis Wickes Hine
—
The kitchen was at the New Jersey Industrial and Manual
Training School for Colored Youth (1876–1955), known
as The Bordentown School, a coeducational college
preparatory and vocational school.

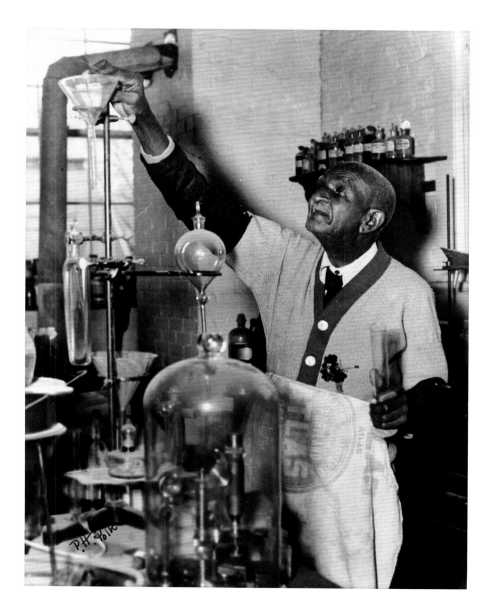

George Washington Carver in Laboratory, ca. 1930
P. H. Polk

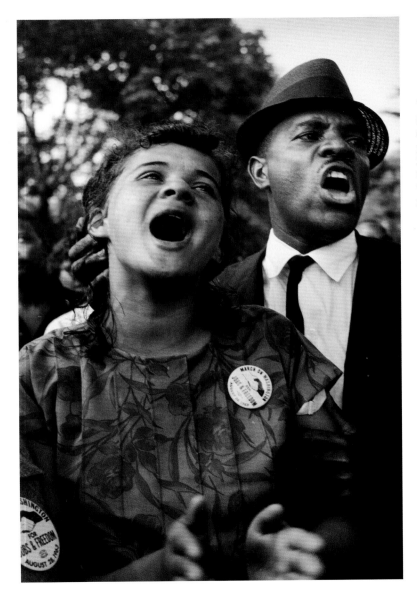

***Washington, D.C. · USA
(March on Washington
8–28–1963)***, printed 2006–9
**Jacquelyn Bond and
Golden Frinks singing
"We Shall Overcome"**
Leonard Freed

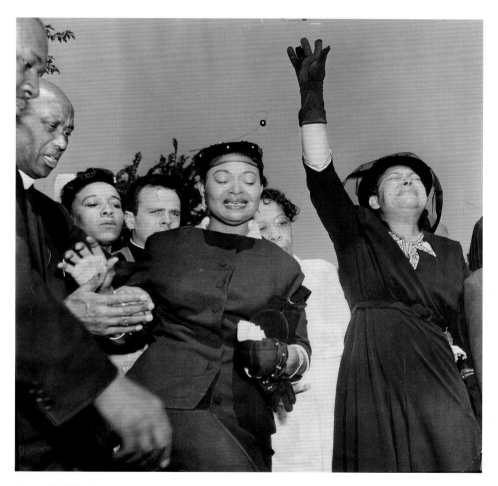

**Emmett Till's funeral,
Burr Oaks Cemetery**,
September 6, 1955
Dave Mann

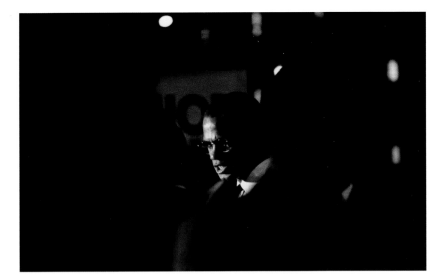

**Malcolm X,
369th Armory,
Harlem**,
1964
Louis H. Draper

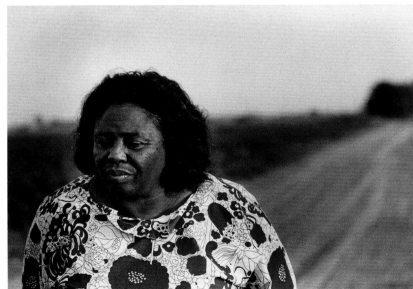

**Fannie Lou Hamer
(Flower Dress)**,
ca. 1960
Louis H. Draper

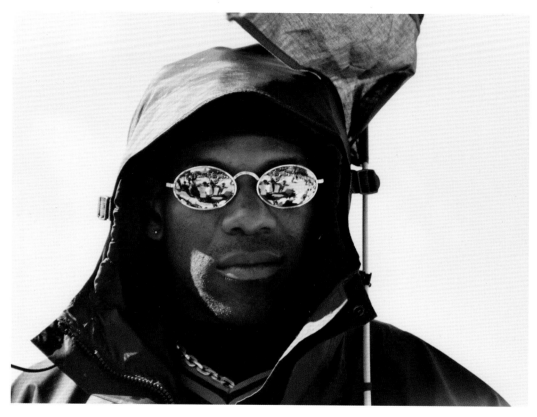

Positive Reflections,
October 16, 1995
From the series
One Million Strong
Roderick Terry

Terry wrote that the series "celebrates black men from all over America, who came together on October 16, 1995, at the Million Man March for a day of atonement and reconciliation."

The Last Night of the March (Dr. and Mrs. King),

1965; printed 1995
Spider Martin

—

Civil Rights organizers of the Southern Christian Leadership Conference (SCLC) and Student Nonviolent Coordinating Committee (SNCC) led a peaceful protest march from Selma, Alabama, to the State Capitol in Montgomery. On the evening before the end of the nearly three-week-long, 54-mile trek, marchers enjoyed a reprieve during an outdoor Freedom Rally that featured celebrities performing to express their support.

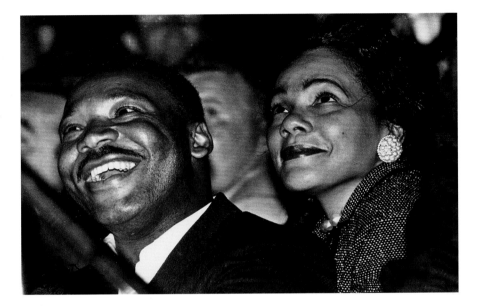

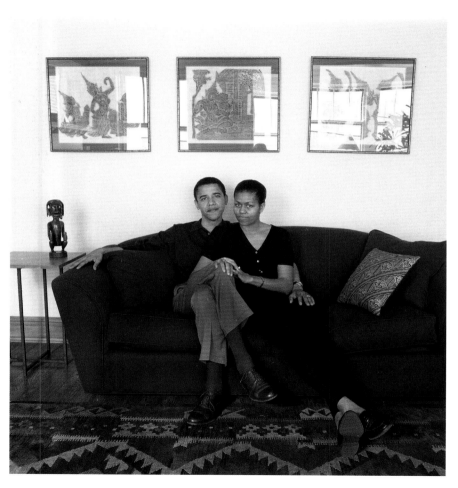

Barack and Michelle Obama, Chicago,
May 26, 1996
Mariana Cook
—

Twelve years before Barack Obama was first elected president of the United States, Mariana Cook photographed and interviewed the Obamas in Chicago. Mrs. Obama told Cook, "We are going to be busy people doing lots of stuff. And it'll be interesting to see what life has to offer."

COMMUNITY

Connections between people can be formed in the most unlikely ways and can be literal or metaphorical. Community reflects the resilience and hope that is part of African American history and culture. This section features people, places, and historic moments that have been sources of refuge and strength for African Americans.

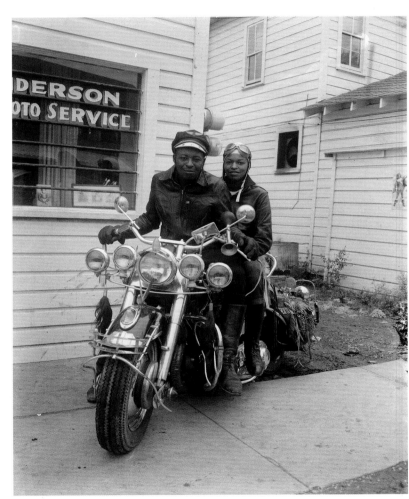

A couple on a motorcycle outside of Anderson Photo Service studio, ca. 1960
Rev. Henry Clay Anderson

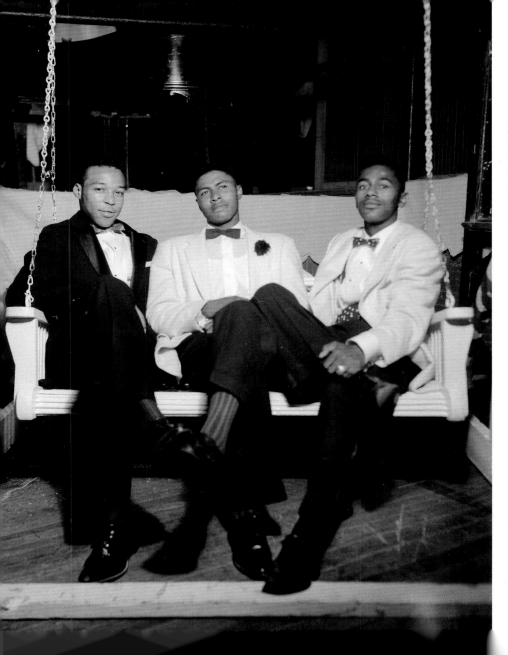

Douglas Burns, Charles Henry Sayles, and Alfred A. Neal sitting on a porch swing, 1958
Rev. Henry Clay Anderson

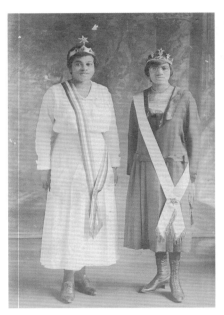

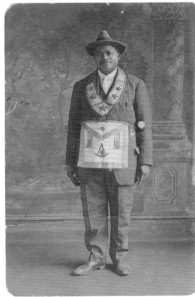

Magdalene Hendricks and her sister in Eastern Star regalia, early 1920s
Unidentified photographer

Daniel Hendricks in Masonic regalia, early 1920s
Unidentified photographer

"It's a testament to the resilience of the human spirit that despite the conditions we have known, despite all the horrors of slavery, despite the sometimes brutal mistreatment blacks have received in this country, we're still here, still managing through it all to find a way to live life with dignity and a certain amount of nobility."

August Wilson, April 15, 1990

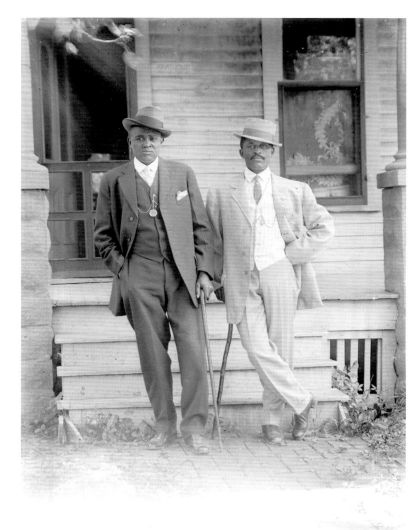

George W. Butcher and friend, 1919–25; scanned 2012
John Johnson

Untitled, 1946–48
**An afternoon game
at Table 2**
From the series
**The Way of Life of
the Northern Negro**
Wayne F. Miller

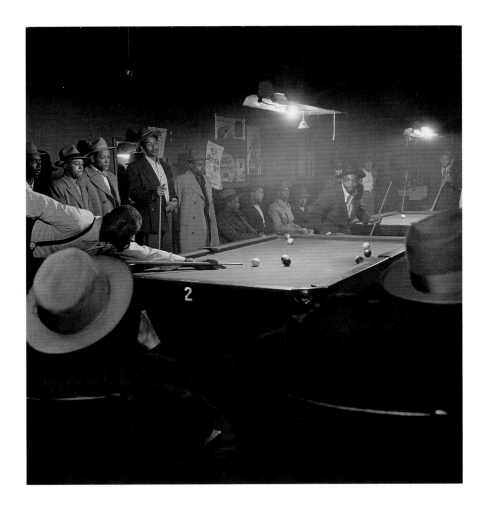

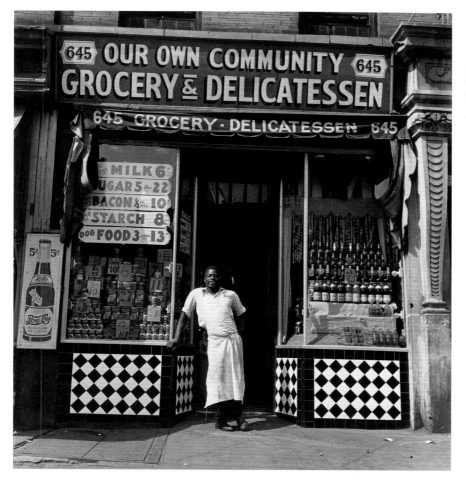

Untitled, ca. 1940–41
From the series
**The Most Crowded
Block in the World**
Aaron Siskind

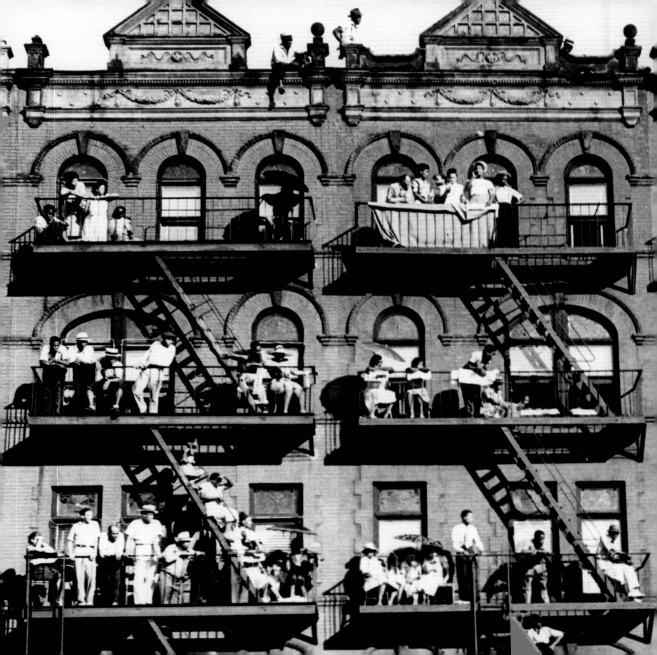

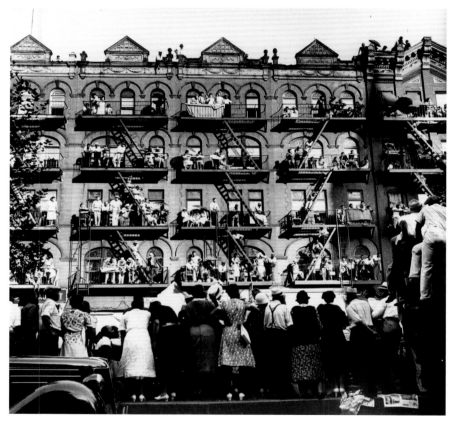

Elks Parade, Harlem, 1938
Jack Manning
—
The parade, a show of pride and citizenship, is pictured featuring not the marchers but rather the viewers. The Improved Benevolent and Protective Order of the Elks of the World had been formed as a separate African American organization when blacks were repeatedly denied participation in white fraternal organizations.

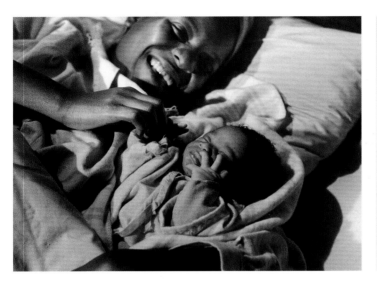

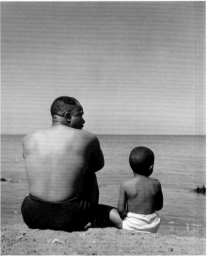

***Untitled (Bonding
with Baby)***, 1952
From the series
**Reclaiming Midwives:
Stills from *All My Babies***
Robert Galbraith

Untitled, 1946–48
**Father and son
at Lake Michigan**
From the series
**The Way of Life of
the Northern Negro**
Wayne F. Miller

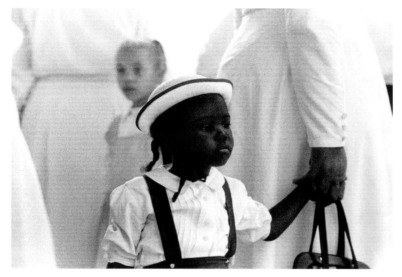

Church Girl, 1966;
printed 2009
George Krause

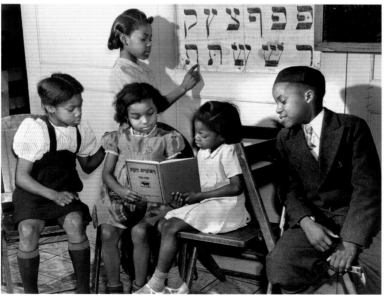

***African American
Jewish Congregation
in Harlem, Children
Studying***, 1940
From the series
**The Commandment
Keepers**
Alexander Alland

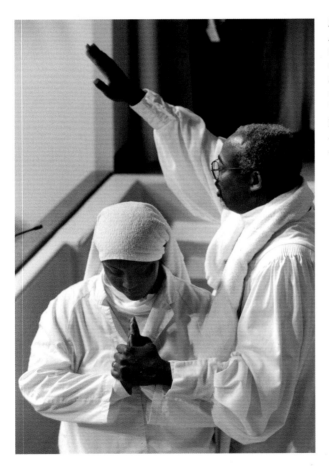

Rev. Edward Y. Jackson Prepares to Baptize a Young Convert at Alfred Street Baptist Church, Alexandria, Virginia, 2003; printed 2012
Jason Miccolo Johnson

Revelations—Opening Section of "Pilgrim of Sorrow" danced to "I Been 'Buked," 1961; printed ca. 1992
Jack Mitchell
—
The dancers left to right are Alvin Ailey, Myrna White, James Truitte, Ella Thompson Moore, Minnie Marshall, and Don Martin.

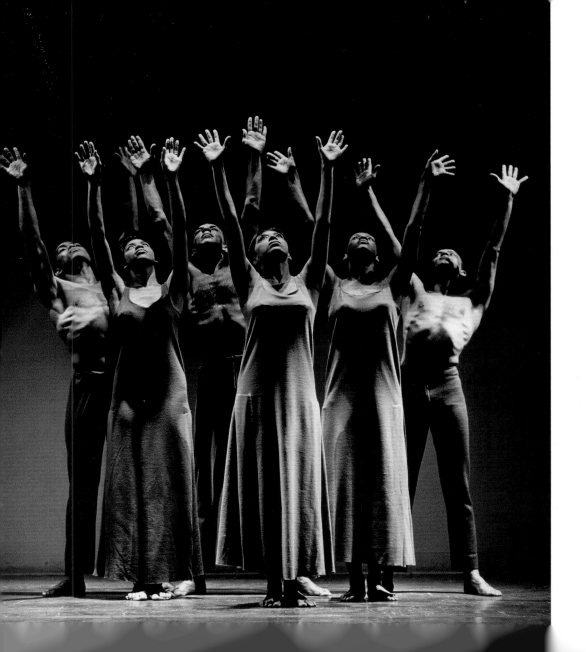

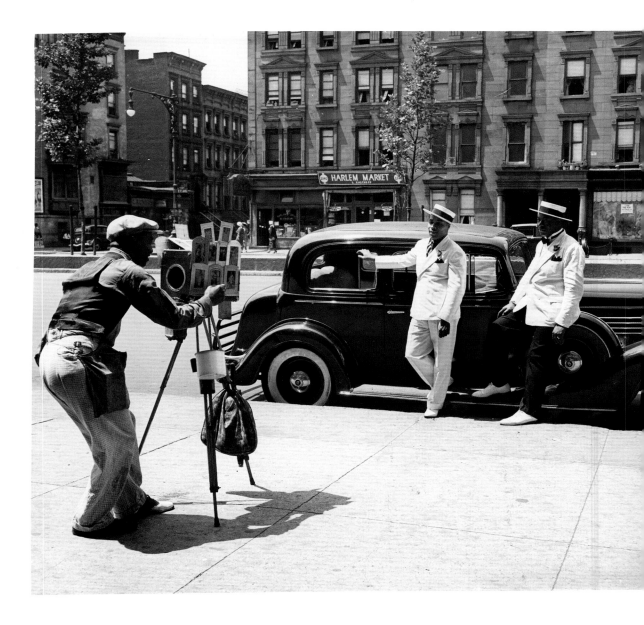

CULTURE

Culture is often expressed through art, dance, theater, music, and film. Throughout various epochs of American history, blacks have used culture to fight for social justice, push for racial equality, and represent the varied lived experiences of African Americans. Images in this section showcase the vibrant legacy of African Americans and highlight the richness and depth of the African American experience.

Photographer Zack Brown Shooting Dapper Men in Harlem, ca. 1937
Eliot Elisofon

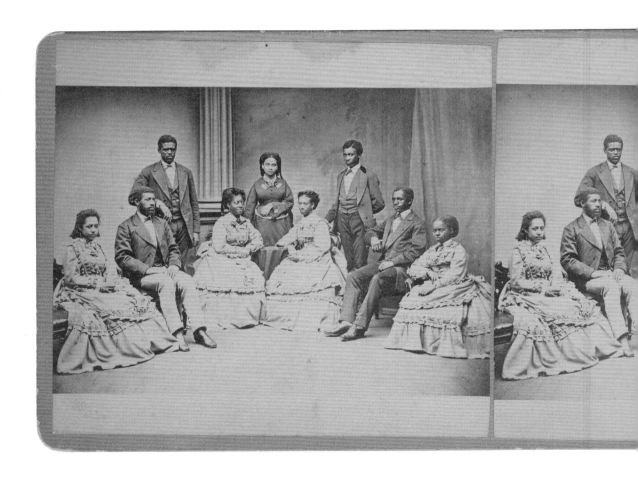

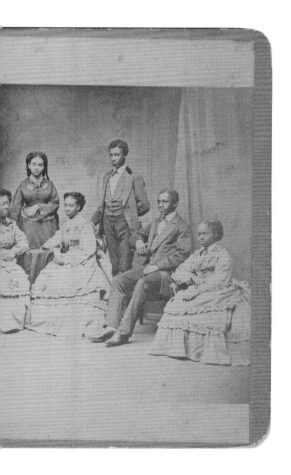

Jubilee Singers, Fisk University, Nashville, Tennessee, 1872
American Missionary Association

"... the Jubilee Singers sang the slave songs so deeply into the world's heart that it can never wholly forget them again."

W. E. B. Du Bois, 1903

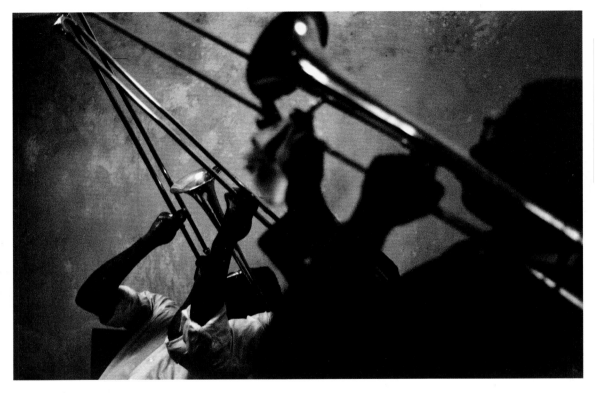

***Untitled (The United House
of Prayer for All People of
the Church of the Apostolic
Faith)***, 1963; printed 2010
Jan Yoors

***At Her Best,
Sarah Vaughan***, 1950
**At the Club Oasis,
Los Angeles**
Joe Schwartz

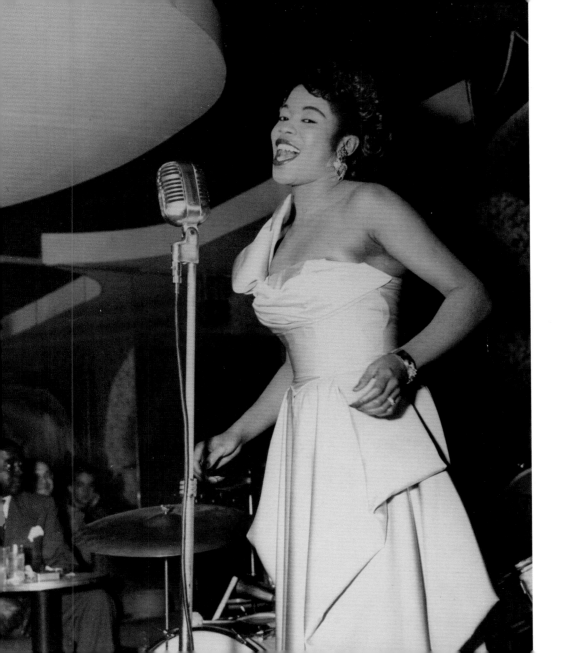

**James Baldwin by His
Typewriter, Istanbul
1966**
Sedat Pakay

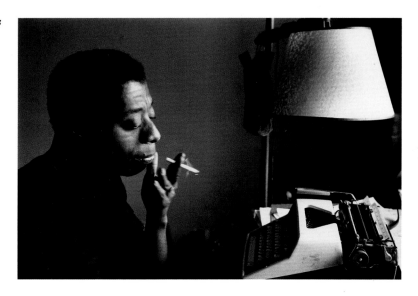

*"The time has come, God knows, for us to
examine ourselves, but we can only do
this if we are willing to free ourselves of
the myth of America and try to find out
what is really happening here."*

James Baldwin, 1961

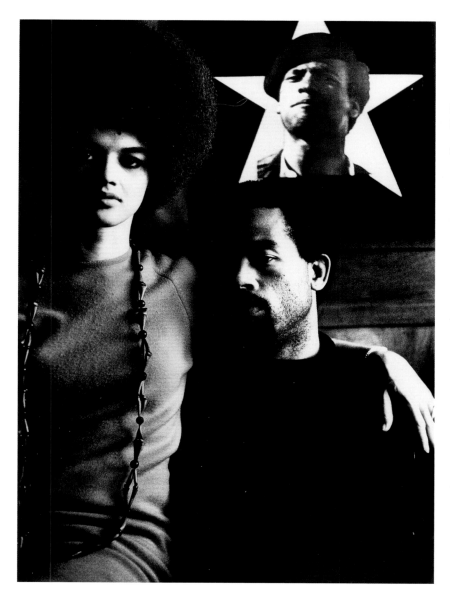

Eldridge Cleaver and His Wife, Kathleen, in Exile, 1970
Gordon Parks

**_Isaac Hayes in
His Office at Stax
Records, Memphis,
Tennessee_**, 1970s
Ernest C. Withers
—
Part of a behind-the-
scenes production
partnership for Stax
Records, Isaac Hayes took
his place on the world
stage as a recording
artist and the voice
of soul music.

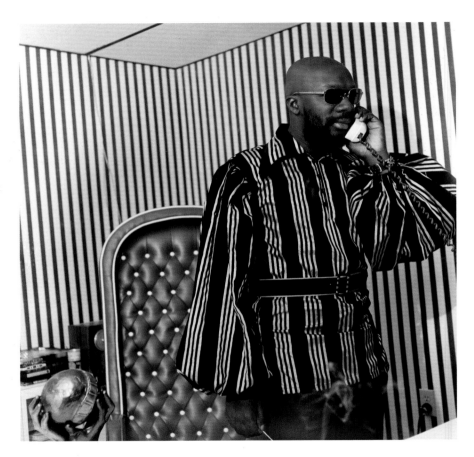

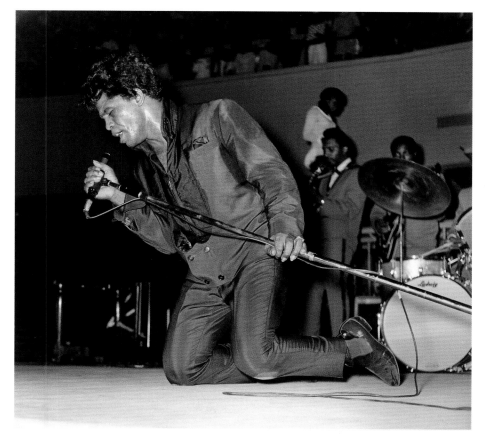

James Brown,
Mid–South Coliseum,
Memphis, Tennessee,
ca. 1965
Ernest C. Withers

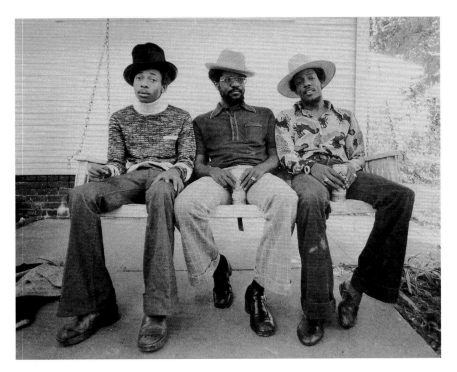

Untitled, 1974;
printed 2012
**The Gap Band, Charlie
Wilson, Ronnie Wilson,
and Robert Wilson**
Gaylord Oscar Herron

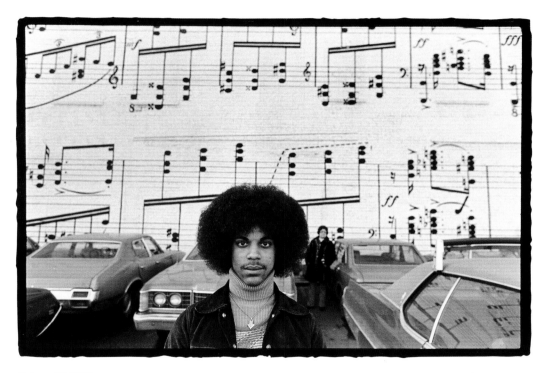

Prince 17, 1977
**Prince outside
Schmitt's Music
Store, Minneapolis,
Minnesota**
Robert Whitman

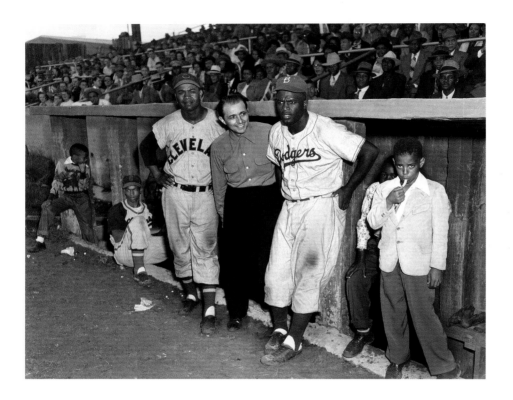

***Ernie Banks, Larry
Doby, Matty Brescia,
Jackie Robinson,
Martin's Stadium,
Memphis, Tennessee***,
1953
Ernest C. Withers

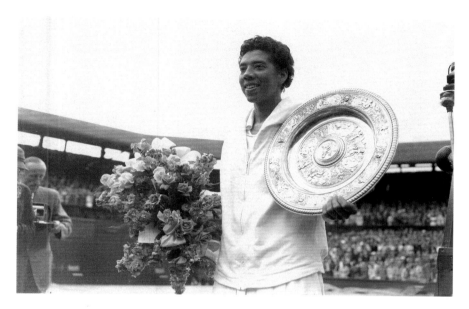

Althea Gibson holding a Wimbledon trophy plate, July 1957
Michael Cole

"[T]he element that links black athletes through time is the legacy of hope. This has been the black athlete's primary contribution to the journey of African Americans: providing a source of hope, a beacon of light."

William C. Rhoden, 2006

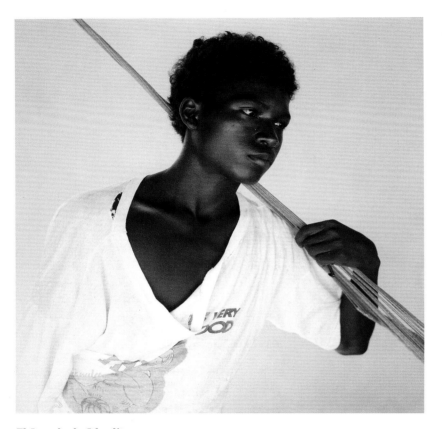

***El Amado de Afrodita,
The Beloved of
Aphrodite, El Ciruelo,
Oaxaca, Mexico***, 1990
Tony Gleaton

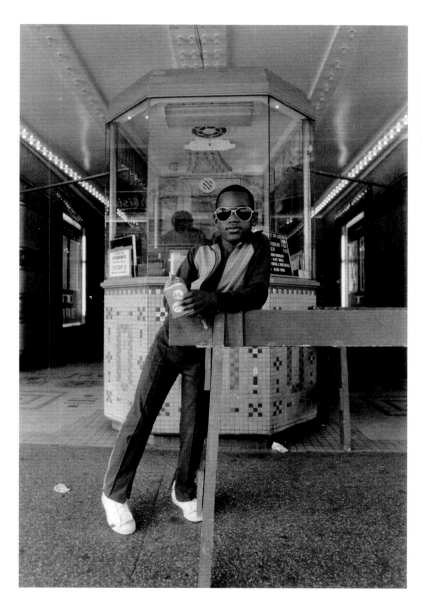

A Boy in Front of the Loews 125th Street Movie Theater, 1976; printed 2005
From the series
Harlem, USA
Dawoud Bey

"I believe in spirit . . . I believe a manifestation of spirit is dance."

Judith Jamison, 1993

Judith Jamison in John Butler's Facets, 1976; printed 1992
Jack Mitchell
—
Judith Jamison performs here one of her most captivating roles for the Alvin Ailey American Dance Theater. Jamison, a talented and prolific choreographer as well as a dancer, succeeded Ailey as artistic director and led the company for more than two decades, from 1989 to 2010.

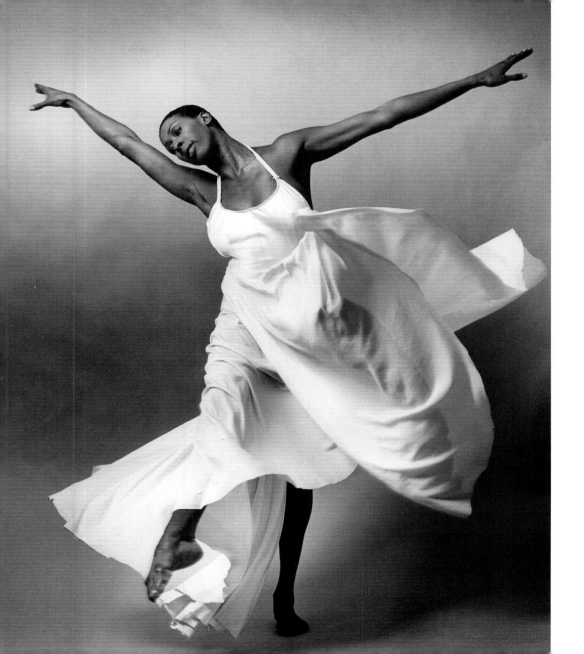

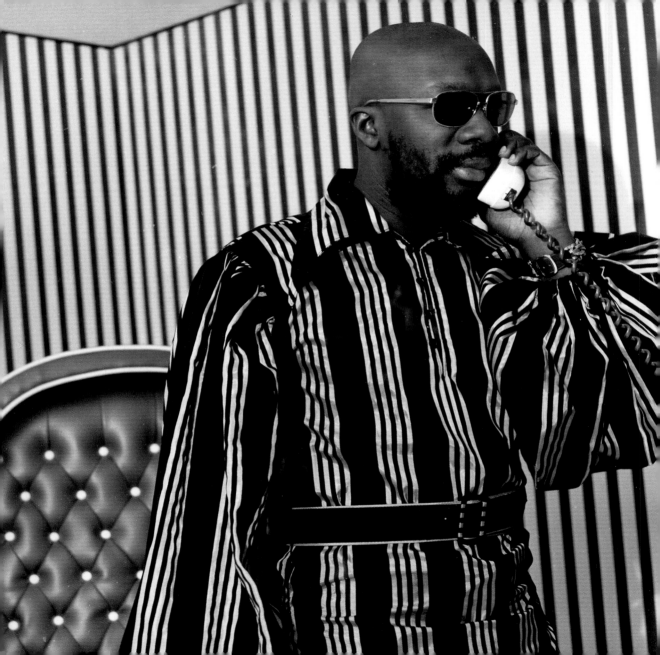

Index

All of the photographic materials are in the collection of the National Museum of African American History and Culture.

Tony Gleaton
El Amado de Afrodita, The Beloved of Aphrodite, El Ciruelo, Oaxaca, Mexico, 1990
digital print
H × W (Image and Sheet):
20 × 16 in. (50.8 × 40.6 cm)
Gift of William and Aimee Lee Cheek in honor of Wendy Susan Cheek
2013.82
© 1990 Tony Gleaton
All rights reserved
Page 72

Gaylord Oscar Herron
Untitled, 1974; printed 2012
Members of The Gap Band, Charlie Wilson, Ronnie Wilson, and Robert Wilson
digital print
H × W (Image and Sheet):
13 × 20¼ in. (33 × 51.4 cm)
Gift of Gaylord Oscar Herron
2012.67.7
© Gaylord Oscar Herron
Page 68

Lewis Wickes Hine
Students working in an industrial kitchen, ca. 1935
gelatin silver print
H × W (Image and Sheet):
5 × 7 in. (12.7 × 17.8 cm)
Gift of Howard & Ellen Greenberg
2011.165.25
Page 38

Illinois Central Railroad
Y. & M. V. R. R. Station Cary, Miss. 5-1-27, 1927
Documentation of the Mississippi River flood
gelatin silver print
H × W (Image and Sheet):
8 ¹⁄₁₆ × 9¹⁵⁄₁₆ in. (20.5 × 25.3 cm)
2011.13.24
Page 30

Illinois Central Railroad
Yazoo City Pan. J8, 1927
Documentation of the Mississippi River flood
eight joined gelatin silver prints
H × W (Image and Sheet):
8 × 80 in. (20.3 × 203.2 cm)
2011.13.21
Page 31 and gatefold

Jason Miccolo Johnson
Rev. Edward Y. Jackson Prepares to Baptize a Young Convert at Alfred Street Baptist Church, Alexandria, Virginia, 2003; printed 2012
gelatin silver print
H × W (Image and Sheet):
19⁹⁄₁₆ × 15⅞ in. (49.7 × 40.3 cm)
2012.141.27
© Jason Miccolo Johnson
Page 56

John Johnson
George W. Butcher and friend wearing suits and leaning on canes, 1919–25; scanned 2012
digitized glass plate negative
2012.56.1.28
© Douglas Keister
Page 49

George Krause
Church Girl, 1966; printed 2009
digital print
H × W (Image and Sheet):
10⅜ × 7⁵⁄₁₆ in. (27 × 18.6 cm)
2011.162.8
© 2009 George Krause
Page 55

Dave Mann
Emmett Till's funeral, Burr Oaks Cemetery, September 6, 1955
gelatin silver print
H × W (Image and Sheet):
8¾ × 8¹¹⁄₁₆ in. (22.2 × 22.1 cm)
Gift of Lauren and Michael Lee
2013.92
© Dave Mann, 1955, Chicago Sun-Times
Page 41

Jack Manning
Elks Parade, Harlem, 1938
gelatin silver print
H × W (Image and Sheet):
11 × 10¾ in. (27.9 × 27.3 cm)
2010.53.3
© Estate of Jack Manning
Pages 52 and 53

Spider Martin
The Last Night of the March (Dr. and Mrs. King), 1965; printed 1995
gelatin silver print
H × W (Image and Sheet):
11 × 14 in. (27.9 × 35.6 cm)
2011.14.16
© 1965 Spider Martin
Page 44

McPherson & Oliver
Gordon under Medical Inspection, 1863; printed later
glass lantern slide in wooden frame
H × W (Slide): 3¼ × 4 in. (8.3 × 10.2 cm)
H × W (Frame): 4¼ × 6⅞ × ⅜ in. (10.8 × 17.5 × 1 cm)
2012.46.52a–b
Page 27

Gjon Mili
Orchestra Playing for Dancers at the Annual National Urban League Ball at the Savoy Ballroom, New York, 1949
gelatin silver print
H × W (Image and Sheet):
10⅜ × 13⅜ in. (26.4 × 34 cm)
2010.53.2
© Time Life Pictures/Getty Images, Inc.
Page 20

Wayne F. Miller
Untitled, 1946–48
An afternoon game at Table 2
From the series **The Way of Life of the Northern Negro**
gelatin silver print
H × W (Image and Sheet):
13¼ × 10⅜ in. (33.7 × 26.4 cm)
2009.24.2
© Wayne F. Miller
Page 50

Wayne F. Miller
Untitled, 1946–48
Father and son at Lake Michigan
From the series **The Way of Life of the Northern Negro**
gelatin silver print
H × W (Image and Sheet):
13¼ × 10⅜ in. (33.7 × 26.4 cm)
2009.24.28
© Wayne F. Miller
Page 54

Unidentified photographer
An African American soldier,
1861–65
tintype
H × W × D (Case open):
3¹³⁄₁₆ × 7 × ⁷⁄₁₆ in. (9.8 × 17.8 × 1.1 cm)
H × W × D (Case closed):
3⅞ × 3⁵⁄₁₆ × ¾ in. (9.8 × 8.5 × 1.9 cm)
Gift from the Liljenquist Family
Collection
2011.51.12
Pages 32 and 33

Unidentified photographer
**Daniel Hendricks in Masonic
regalia**, early 1920s
albumen postcard
H × W (Image and Sheet):
5⅜ × 3⁷⁄₁₆ in. (13.7 × 8.7 cm)
Gift of Robin J. Boozé Miller
2011.72.3
Page 48

Unidentified photographer
Frederick Douglass, 1855–65
ambrotype
H × W × D (Case open):
4¾ × 7¹¹⁄₁₆ × ½ in.
(12.1 × 19.5 × 1.3 cm)
H × W × D (Case closed):
4¾ × 3⅞ × ¾ in. (12.1 × 9.8 × 1.9 cm)
2010.36.10
Page 25

Unidentified photographer
**Magdalene Hendricks and her
sister in Eastern Star regalia**,
early 1920s
albumen postcard
H × W (Image and Sheet):
4¾ × 3¼ in. (12.1 × 8.3 cm)
Gift of Robin J. Boozé Miller
2011.72.4
Page 48

Unidentified photographer
Pauline C. Cookman in uniform,
ca. 1950
hand-tinted gelatin
silver print
H × W (Image and Sheet):
6¹³⁄₁₆ × 5 in. (17.3 × 12.7 cm)
2011.155.135
Page 35

Unidentified photographer
Sojourner Truth, 1864
gelatin silver cabinet card
H × W (Image and Mount):
6½ × 4½ in. (16.5 × 10.8 cm)
2013.207.1
Page 11

Unidentified photographer
A woman with a young boy, 1865
albumen cabinet card
H × W (Image and Mount):
3¹¹⁄₁₆ × 2⅛ in. (9.4 × 5.4 cm)
Gift of Linda and Artis Cason
2011.30.2
Page 28

James H. Wallace
July 4 March through Chapel Hill,
July 4, 1964; scanned 2010
(JWCR-021.28)
digitized acetate negative
Gift of James H. Wallace Jr.
2011.11.6
© Jim Wallace
Page 24

Augustus Washington
A young woman, ca. 1850
daguerreotype
H × W × D: 2⅞ × 2½ × ⁵⁄₁₆ in.
(7.3 × 6.4 × 0.8 cm)
2010.16
Page 18

Robert Whitman
Prince 17, 1977
**Prince outside Schmitt's
Music Store, Minneapolis,
Minnesota**
gelatin silver print
H × W (Image and Sheet):
20 × 24 in. (50.8 × 61 cm)
2011.78
© Robert Whitman
Page 69

Ernest C. Withers
*Ernie Banks, Larry Doby, Matty
Brescia, Jackie Robinson, Martin's
Stadium, Memphis, Tennessee*, 1953
gelatin silver print
H × W (Image and Sheet):
16 × 20 in. (40.6 × 50.8 cm)
2009.16.14
© Ernest C. Withers Trust
Page 70

Ernest C. Withers
*Isaac Hayes in His Office at Stax
Records, Memphis, Tennessee*, 1970s
gelatin silver print
H × W (Image and Sheet):
20 × 16 in. (50.8 × 40.6 cm)
© Ernest C. Withers Trust
2009.16.24
Pages 66 and 76

Ernest C. Withers
*James Brown, Mid-South
Coliseum, Memphis, Tennessee*,
ca. 1965
gelatin silver print
H × W (Image and Sheet):
16 × 20 in. (40.6 × 50.8 cm)
2009.16.25
© Ernest C. Withers Trust
Page 67

Jan Yoors
*Untitled (The United House
of Prayer for All People of the
Church of the Apostolic Faith)*,
1963; printed 2010
digital print
H × W (Image and Sheet):
10⅞ × 13¹⁵⁄₁₆ in.
(27.6 × 35.4 cm)
2011.162.4
© 1965 Jan Yoors
Page 62